BORROWED LIGHT

BARBARA ERNST PREY

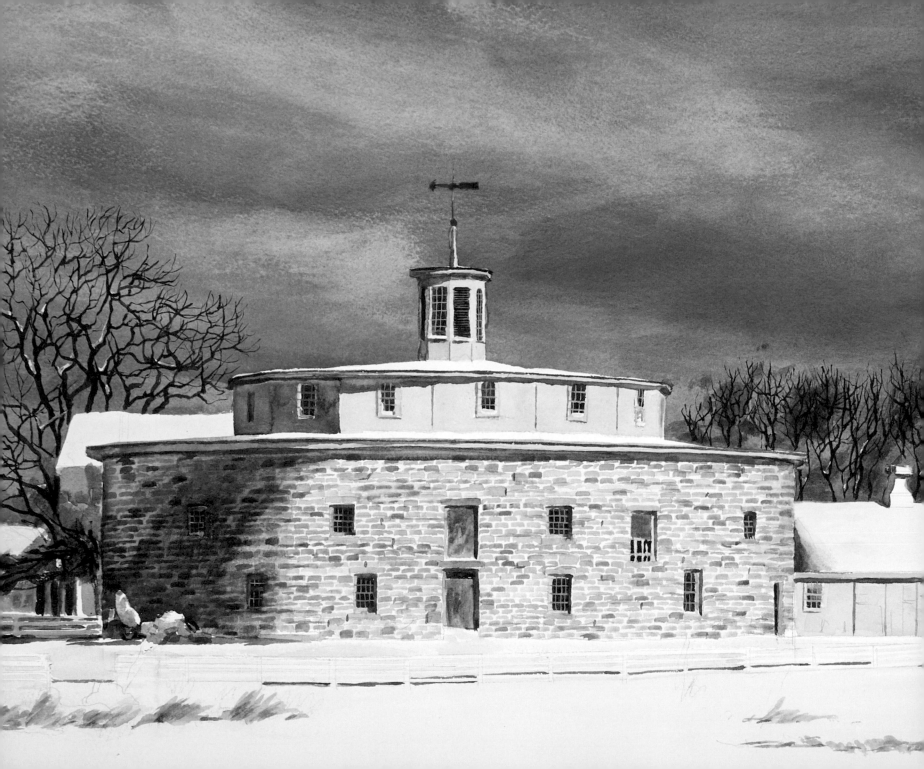

BORROWED LIGHT

BARBARA ERNST PREY

Essays by Sarah Margolis-Pineo
and Charles A. Riley II, PhD
Foreword by Jennifer Trainer

HANCOCK SHAKER VILLAGE
PITTSFIELD, MASSACHUSETTS

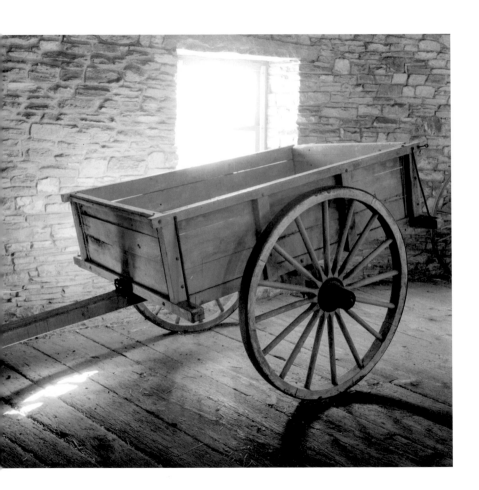

This publication accompanies the exhibition *Borrowed Light: Barbara Ernst Prey*, organized by Hancock Shaker Village, Pittsfield, MA, and exhibited May 17–November 11, 2019.

Hancock Shaker Village
PO Box 927
Pittsfield, MA 01202
HancockShakerVillage.org

Edited by L. J. Calverley
Designed by Lisa Carta
Printed and bound by Puritan Press, Inc.

Image credits
Cover: Barbara Ernst Prey, *Channeled Light* (detail), 2019. Watercolor and drybrush on paper, 38 ½ x 58 ½ inches. Courtesy of Barbara Prey Studio.
Photography © Barbara Prey Studio
Title page: Barbara Ernst Prey *Shaker Barn* (detail), 2019. Watercolor and drybrush on paper, 40 x 60 inches. Courtesy of Barbara Prey Studio.
Photography © Barbara Prey Studio
Pages 9 – 41: Artwork by Barbara Ernst Prey, photography © Barbara Prey Studio
Photography: Dante Birch, page 32; Jack Criddle, page 34; Michael Fredericks, pages v, vi, 2, 3, 11, 37; Paul Rocheleau, pages 7, 10; Nick Whitman, pages iv, 4

ISBN-13: 978-0-9832394-2-0

Contents

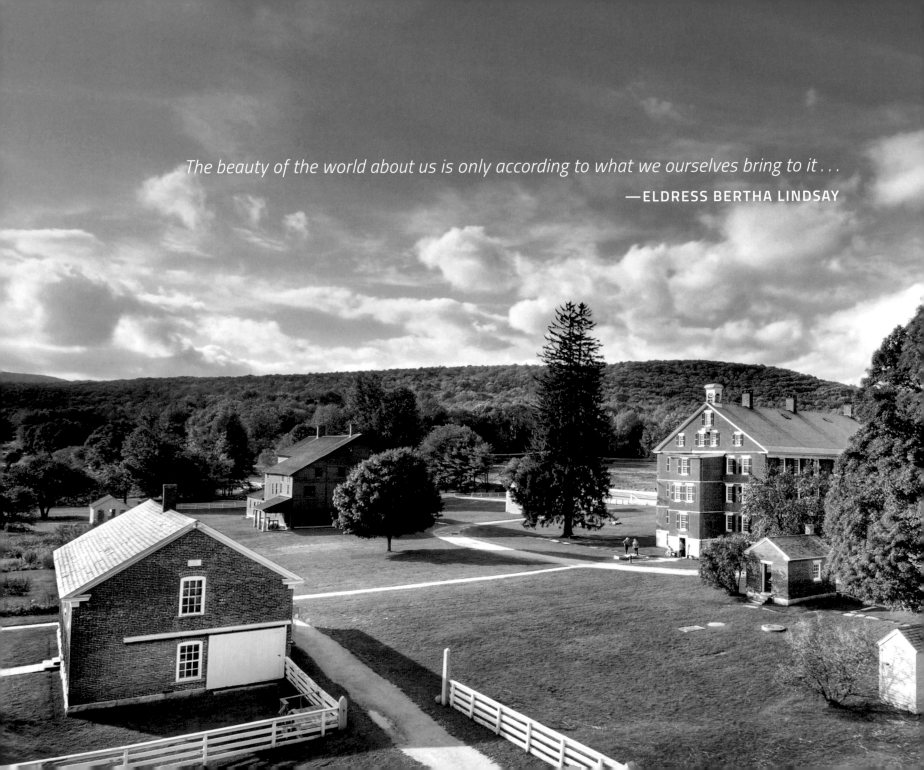

The beauty of the world about us is only according to what we ourselves bring to it . . .
—ELDRESS BERTHA LINDSAY

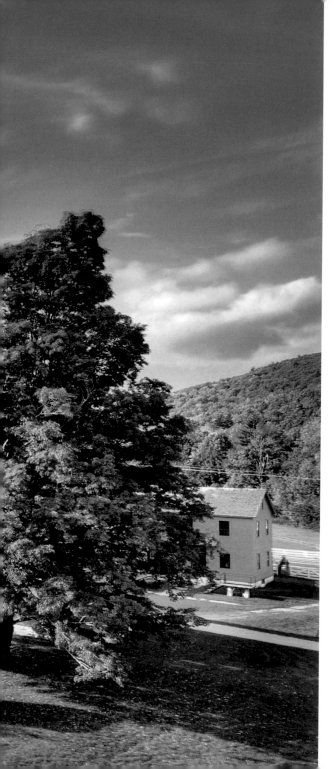

Foreword

There is something visceral that happens when you walk through Hancock Shaker Village, which, for 176 years, was home to the intense religious calling of one of the most successful communal societies in America.

Perhaps it is the history: our intuitive awareness of the fabric of time and rhythmic remnants of a daily life that consisted of tending the cows, sowing the gardens, making everything from ladder-back chairs to music. Perhaps it is the quiet view: a vast flat landscape ringed by mountains and dotted with minimalist architecture that is all right angles and exuberant color. Certainly it is the quality of light, which follows wherever you go, dancing ahead, surprising you in quiet spaces, making its presence physically known. It's subtle, but immersive, completely drawing you in.

Several years ago, as I walked through the Brick Dwelling with our curator and absently touched the built-in furniture, thinking of the hands that created it, I said, "It feels as if the Shakers just left."

"No," she replied with the hint of a sly smile, "it feels as if they are still here." She was right.

The Shakers established themselves in 1774 in New York City when a charismatic woman named Ann Lee and a small band of followers of the movement

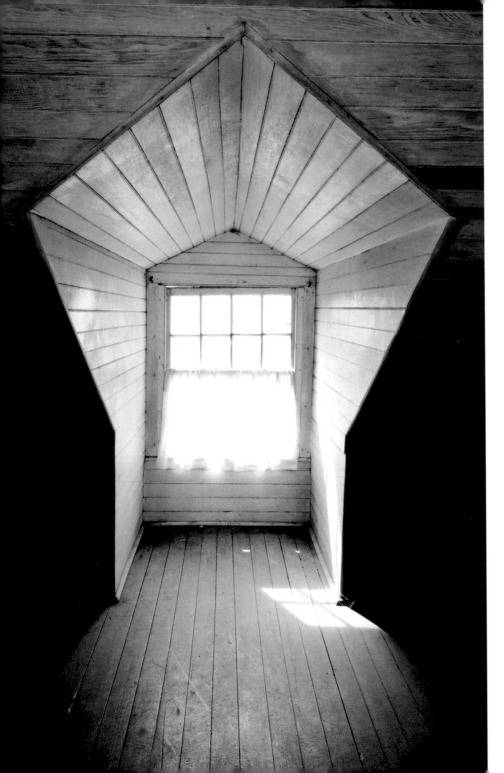

emigrated from Manchester, England. They sailed up the Hudson River to Albany and, within nine years, had settled in Hancock, developing a system of communal living with rules governing all aspects of life. They were extraordinarily progressive, believing in gender and racial equality, pacifism, and sustainability centuries before others would take up these causes. Putting their "hands to work and hearts to God," the Shakers were talented architects and designers, making furniture that to this day conveys simplicity, diligence, and beauty in the turn of a rail or the curve of an oval box. They designed beautiful buildings that "borrowed light" from God and invited "a plentiful radiance that makes objects inside appear to turn from matter to spirit and vice versa," as noted by photographer Abelardo Morell, whose work was exhibited at the Village in 2018.

Artist Barbara Ernst Prey spent much of the winter of 2018 and spring of 2019 at Hancock Shaker Village, finding and painting the light. Prey continues a tradition at the Village of respectful collaboration between Shaker values and the art world as part of an ongoing program that invites artists of today, such as Maya Lin, David Teeple, and Reggie Wilson, to reflect on the living legacy of the

Shakers. Each responds through his or her own creative lens to the rich Shaker history embodied by the Village's archives, buildings, and grounds.

Borrowed Light helps us to find a shared humanity. The quality of light that shaped the everyday perception and imagination of the Shakers continues to do so today. Prey encourages us to focus on the perceptual experience of Hancock Shaker Village—it takes time and a meditative approach to perceive the full effect. She invites us to reflect on her work, to walk through the Village and find what she has seen, and to then attune ourselves to what we alone might see. Her exhibition helps us to see borrowed light, as well as inner light, and reexamine the things we may have ceased to notice, much less consider.

Jennifer Trainer
Director
Hancock Shaker Village

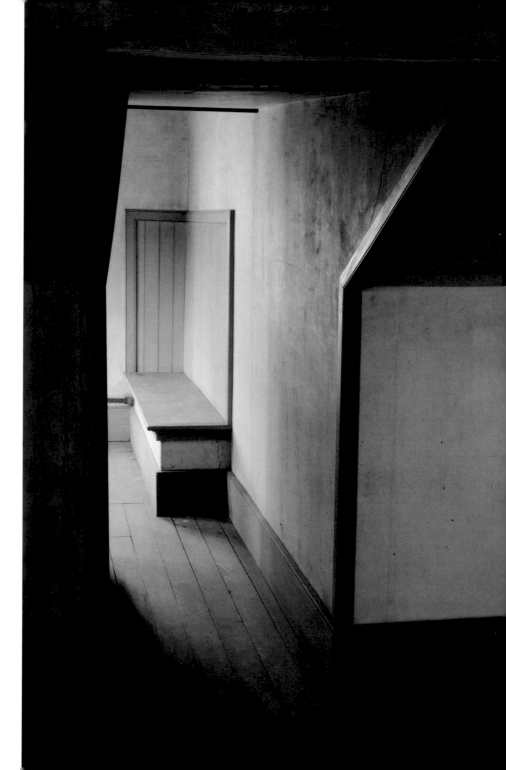

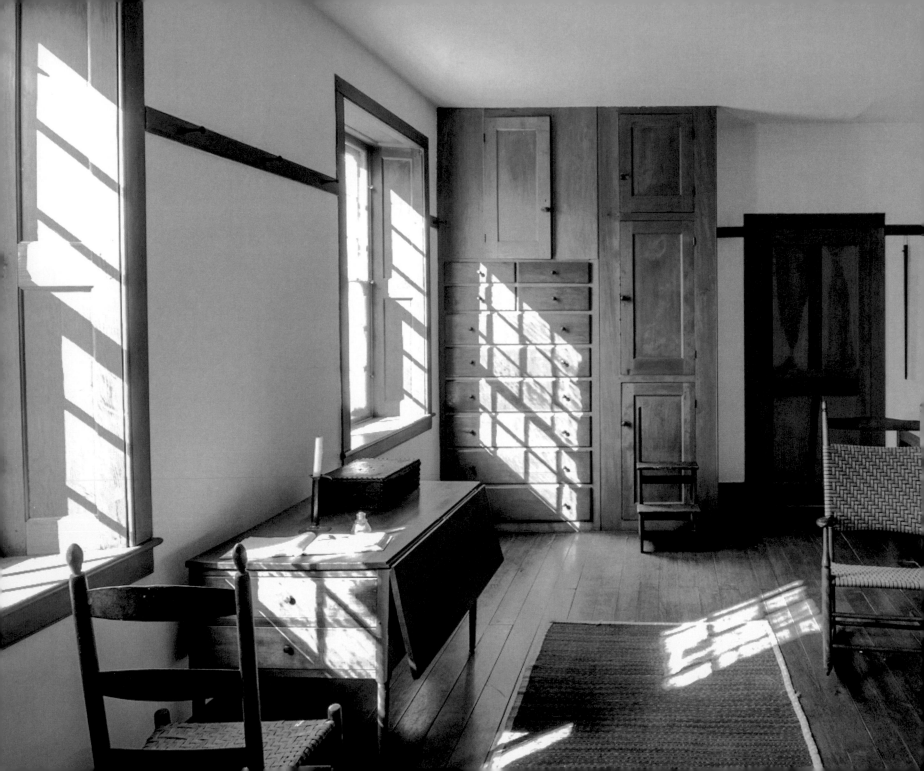

A Special Manifestation of Divine Light

"A Special Manifestation of Divine Light" heralded an auspicious new beginning for Ann Lee, a factory worker from Manchester, England, who in 1774 guided a small group of religious dissenters to America and became the leader of the United Society of Believers in Christ's Second Appearing, more commonly known as the Shakers. Under the guidance of "Mother Ann," the Shakers would transform from a rogue band of European outsiders to a robust radical spiritual movement that continues to serve as a touchstone for American utopian ideals, including passivism, sustainability, gender equality, and religious freedom.

Though Lee's leadership was brief (she passed away in 1784), the idea of light as a manifestation of spirit has remained at the heart of Shaker thought over subsequent centuries. Fervent millennialists, the Shakers believe that Christ has come again through individuals who are open to the anointing of His spirit—notably Mother Ann herself.[1] In the decades following their

settlement near Albany, New York, the Shakers' goal became the construction of the perfect earthly society—a veritable heaven on earth. This spurred them to establish nineteen communities from Maine to Kentucky (including Hancock, Massachusetts), where the Shakers created environments that merged matter and spirit, work and worship.

In religious texts, personal testimonies, and visionary "gift" drawings, the Shakers describe paradise as a radiant realm—"mansions of light"—immaculate, united, and harmonious. So, too, their New World Zion embraced the idea that light is a space where God dwells, and Shaker architecture incorporated sunlight as a conduit connecting heavenly spiritual thought and earthly physical space. This was achieved through the innovative use of windows and skylights built into both interior and exterior walls. Known as the architectural technique of "borrowed light," the result was both pragmatic and sublime—rays of light cut through dim interiors to yield illumination with an ethereal effect.

Renowned for its elemental simplicity, Shaker architecture reduces spaces to their austere essence, containers for—as well as physical manifestations of—the religious dogma that created them. The interiors of Hancock Shaker Village convey a sense of order, calm, and beauty. Precise symmetry designating separate but equal male and female realms, combined with the regulated placement of windows,

creates a profound sense of uniformity accentuated by the optical pattern of illumination. Architectural historian Henry Plummer refers to this phenomenon as the "ritualized choreography" of Shaker interiors, an effect "analogous to a Christian plainsong, or Georgian chant, whose resonating tones help a person escape ordinary consciousness, and enter into a contemplative, even transcendental state of mind."[2]

In this environment, even the most mundane objects express a sense of spiritual magnificence. Shaker ladderback chairs, brooms, and spools of thread become sites of contemplation—perceived as celestial archetypes against the backdrop of white plaster walls. Not wary of color, the Shakers used marigold yellow and red ochre to accent interiors, staining floorboards, peg rails, and built-in cabinets with golden hues. These chromatic flashes along the perimeter of rooms bring to mind the dawning and setting of the sun each day; once again, intentional threads unite heaven and earth, bringing an infusion of spirit into the prescriptive vocabulary of the Shaker material world.

Artist Barbara Ernst Prey (b. 1957) has been drawn to the architecture of worship throughout her career. From the whitewashed vernacular churches of Maine to the ornate Baroque cathedrals of central Europe, Prey remains entranced by the effect of space and light on the human psyche, and it is this ongoing fascination that led her to Hancock Shaker

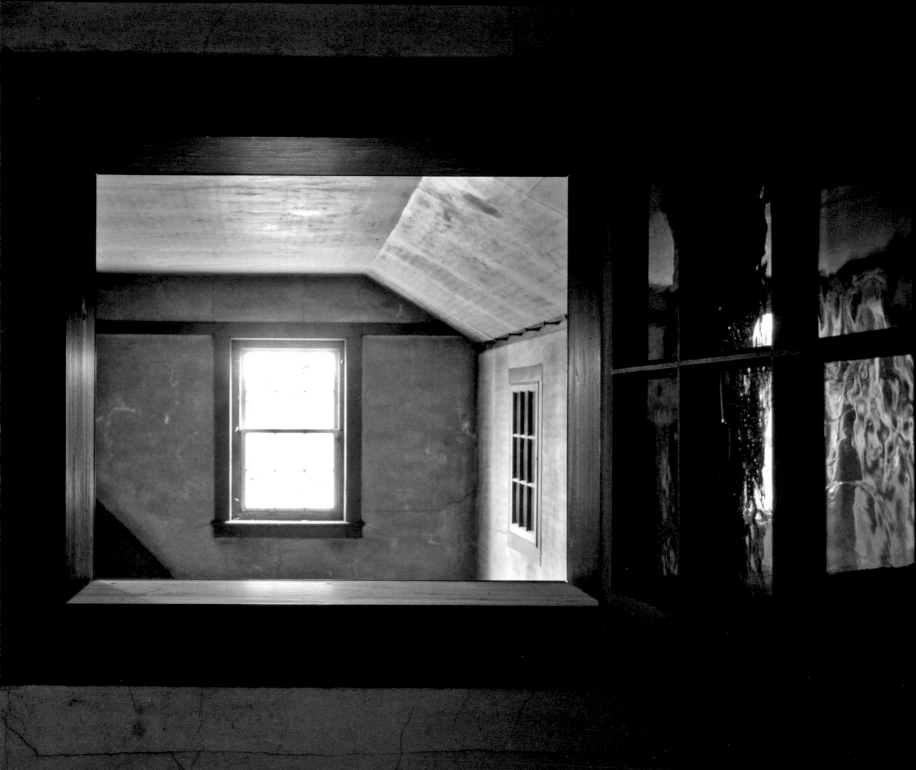

Village and the spiritual utopian design of the Shakers. She first visited as a Williams College student in the late 1970s and subsequently has returned on numerous occasions—in every season and at all times of day—to immerse herself in the landscape and built environment of the Village.

At its essence, Prey's presentation *Borrowed Light* is an exploration of spirit and the shared human desire to feel connected to the universe in a larger and more meaningful way. The exhibition lends new insight into the visual and haptic experience of sacred design, featuring objects and spaces that appear enlivened by a luminosity that can only be divine. On a cold day in December 2018, Prey and I spent hours exploring a frozen Hancock Shaker Village—she with her sketchpad, I with my white gloves. I made slight rearrangements to displays of Shaker boxes, garments, tools, and domestic objects as she acutely observed and sketched the angular refractions of light migrating slowly across a space. In the dim winter light, an astonishing palette of color emerged from what I'd previously seen as pallid wood, drywall, and stone. Violet and emerald were awash in the Laundry and Machine Shop; indigo and gold in the Brick Dwelling; slate and amber in the Sisters' Dairy & Weave Shop.

We look to artists to open up new ways of seeing and understanding the world. Though inspired by the specificity of Hancock Shaker Village, *Borrowed Light* reveals light as universally profound—not only giving life, but also allowing the human spirit to evolve and transform. This body of work is the culmination of a decades-long project, as Prey delves deeper into her exploration of the intersections between the earthly realm and what exists beyond. Traveling through time and space, the artist's monumental watercolors merge the visible and invisible, speculating on the radiant light that shines into darkness and what it means to experience illumination, every day.

Sarah Margolis-Pineo
Curator
Hancock Shaker Village

[1] The Sabbathday Lake Shakers, "Who are the Shakers?" *The Shakers: From Mount Lebanon to the World* (New York: Skira Rizzoli, 2014), p. 10.

[2] Henry Plummer, *Stillness & Light: The Silent Eloquence of Shaker Architecture* (Bloomington: Indiana University Press, 2009), p. 5.

Light on Loan
The Shaker Hymns of Barbara Ernst Prey

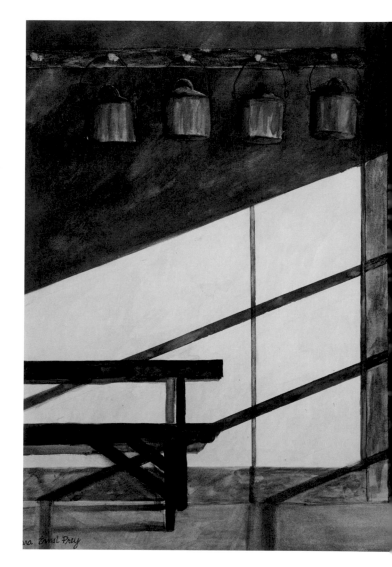

How do you paint an *ethos*? Poetry and drama are natural media for this challenge (think of Greek tragedy or epic poetry). Music and dance hover close to ritual expression (gospel, Bach's Passions, even Doris Humphrey's masterful 1930 dance work, *The Shakers*). Setting aside overt narratives drawn from religious sources (the acres of nativities, depositions, Madonnas, etc., in the Louvre alone), painting is an unusual medium for expressing a belief system. One of the reasons that Barbara Ernst Prey's bold and eloquent exhibition is so noteworthy is the uncanny accomplishment of putting an *ethos* on paper. It takes not just consummate technique to make this convincing; it also requires the highest level of empathy that understanding the relationship between art and belief can offer, a depth of understanding that might otherwise go underappreciated in the sheer enjoyment of the virtuosity of these works.

There is an intellectual grasp of the significance of the material that should not surprise those who are familiar with Prey's educational back-

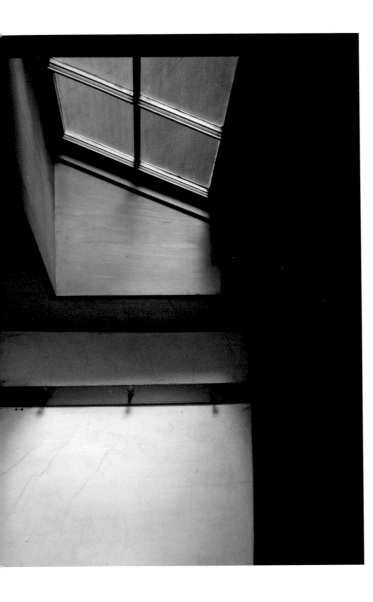

ground: among the areas she explored in the Williams College art history program were medieval art and, in particular, the aesthetics of the cloister. She relayed to me the intriguing anecdote that she was listening to a scholarly text on Bach while she painted the works in this exhibition. She brings the ideal academic background, offering a world-historical context to an all-American project.

The entry and exit points for our understanding of how Prey has captured this spiritual essence are keyed to the relationship between place (*topos*) and *ethos*. While Hancock Shaker Village is more than a motif for a major artist like Prey, it is not a theater set. Each detail is imbued with a thorough, living connection to a way of life grounded in belief. She started with the place itself and delivered a *paysage moralisé* that plays interiors off the exterior, pulled-back view of the iconic Round Stone Barn. Prey applies an incisive eye and ready hand to the Shaker milieu.

Empty rooms fill with imagined activity, as in *Channeled Light* (2019), with its resonant stillness and arresting detail (that one white cloth hung over the wooden bucket). Transparent washes of watercolor (the pun is irresistible) invoke the ethereal aspect of an *ethos* even as the substance of objects and materials is rendered in convincing detail, from the old steel of the long water pipe to the different colors and grains of the wood found in the shelf, floor, and wall. A red coat offers the chromatic top note for a glimpse inside the old Schoolhouse, where lunch pails hang on the wall. The vivid colors of spooled thread remind us that human history, going back tens of thousands of years to the discovery of the first ceremonial garments, weaves color, art, and textiles.

Viewing this exhibition, I am reminded that the only other time I felt that a certain *ethos* was expressed by painting was similarly through works on paper, in the seventeenth-century Chinese Taoist classic *The Mustard-Seed Garden Manual of Painting*. I relate the mimetic accuracy of Prey's strokes to the scholarly *keng hua* style, which has as its goal nothing short of the evocation of the elusive *qi* (spirit or life principle). Prey shared that she has a copy of the book, which she used while studying with a master Chinese painter in Taiwan.

Prey is fascinated by the Shaker phrase "borrowed light," and some of the most unforgettable works in this eponymous presentation feature a raking light that slips dramatically across the wall and floor, catching the folds of a blue jacket and casting crisp black shadows in a precise rhythm. The poetry of Emily Dickinson would not be out of place in this context: "There's a certain slant of light..."

Charles A. Riley II, PhD
Director
Nassau Museum of Art

Charles A. Riley II, PhD, is director of the Nassau Museum of Art (Roslyn, NY), the author of thirty-five books on art, literature, music, and philosophy, and a professor at Clarkson University.

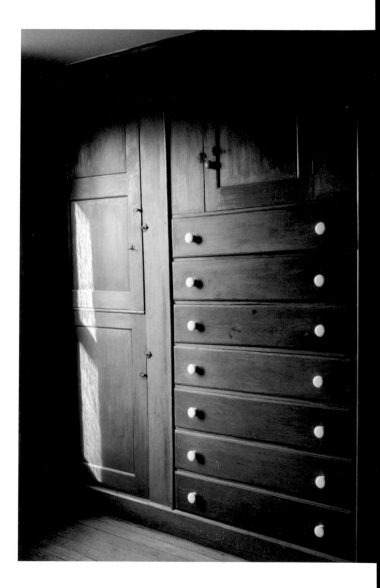

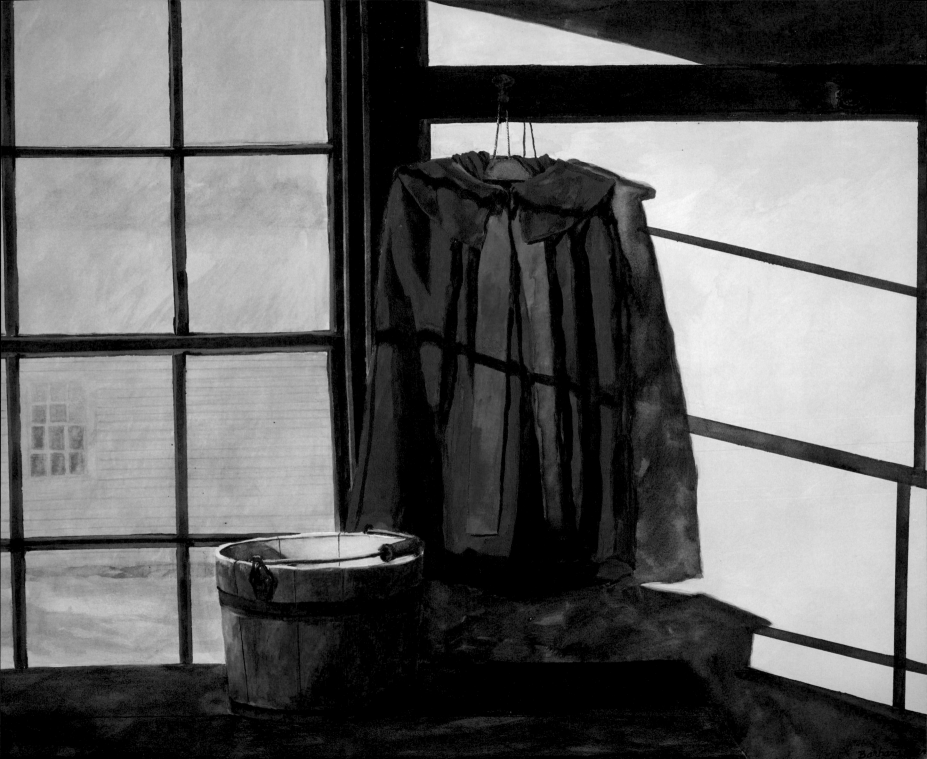

Plates

Red Cloak Blue Bucket, 2019. Watercolor and drybrush on paper, 29 ¾ x 41 inches

Channeled Light, 2019. Watercolor and drybrush on paper, 38 ½ x 58 ½ inches

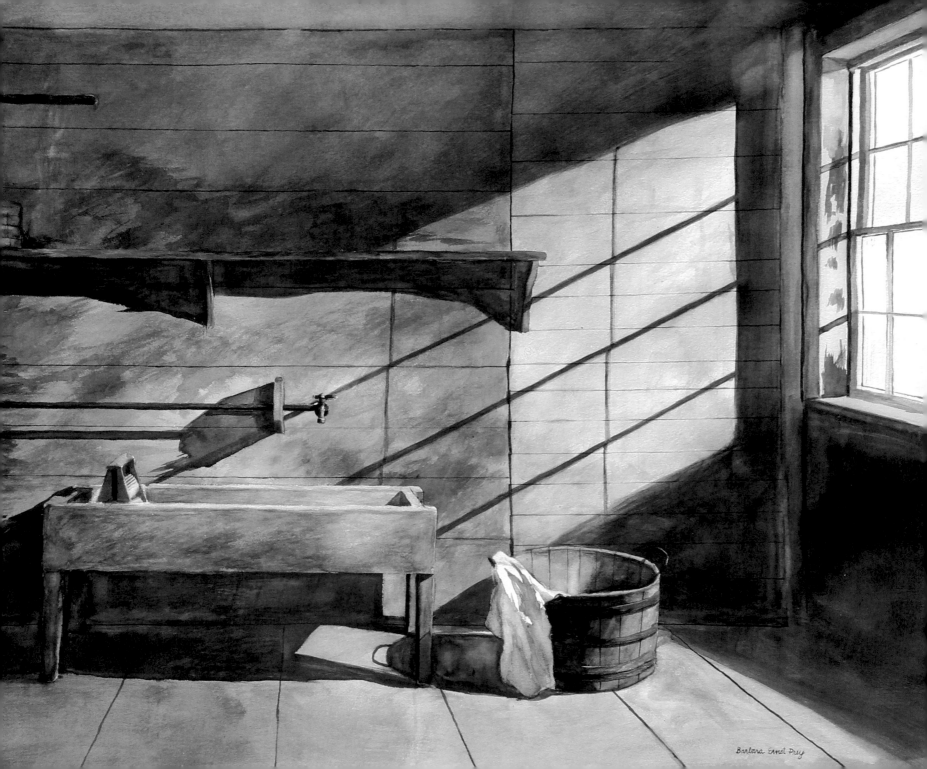

Barbara Ernst Prey

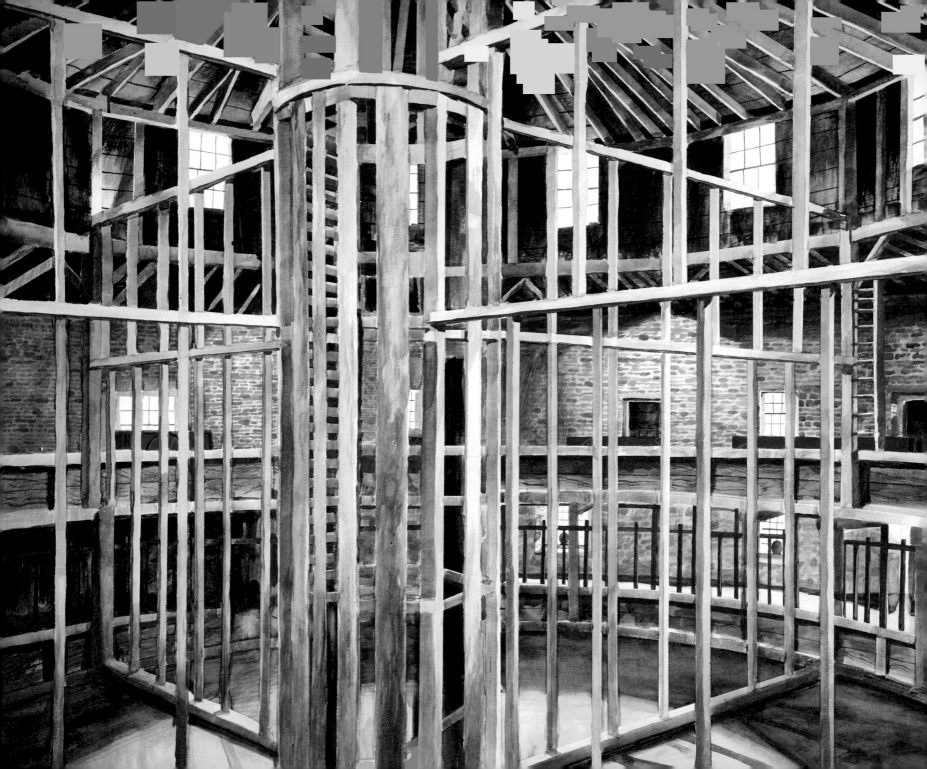

Wood Work, 2019. Watercolor and drybrush on paper, 40 x 60 inches

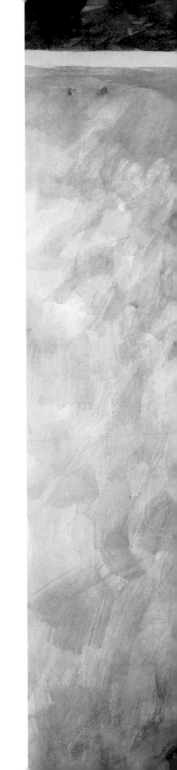

Work of Whimsy, 2019. Watercolor and drybrush on paper, 29 ¾ x 41 inches

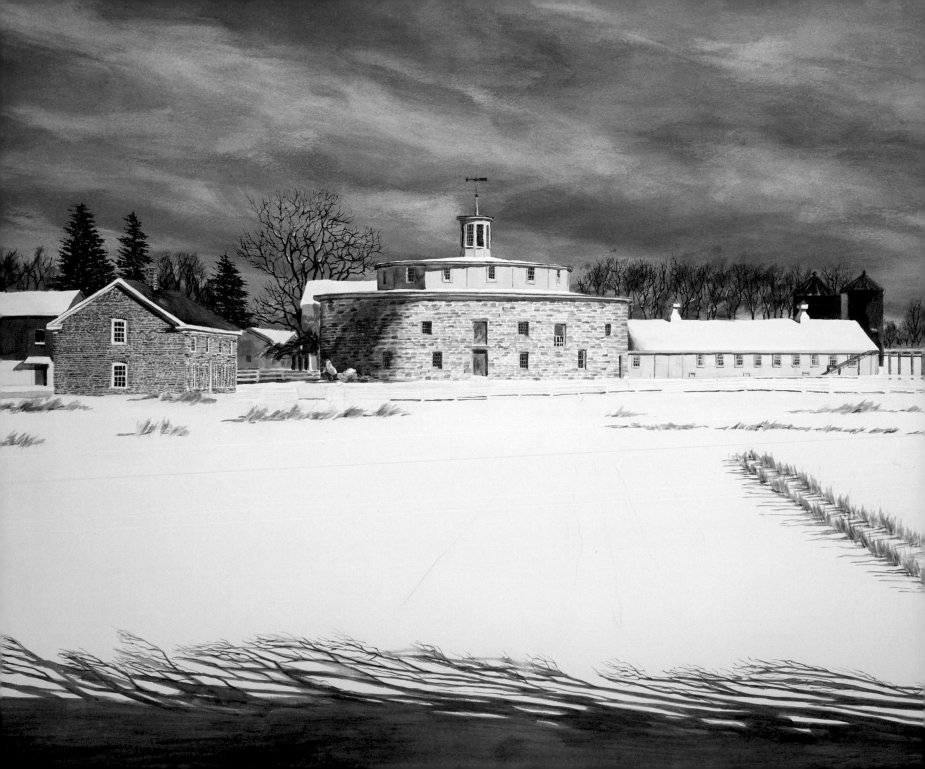

Shaker Barn, 2019. Watercolor and drybrush on paper, 40 x 60 inches

Day's Work, 2019. Watercolor and drybrush on paper, 40 x 60 inches

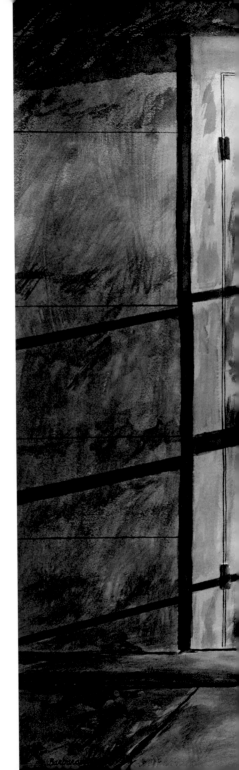

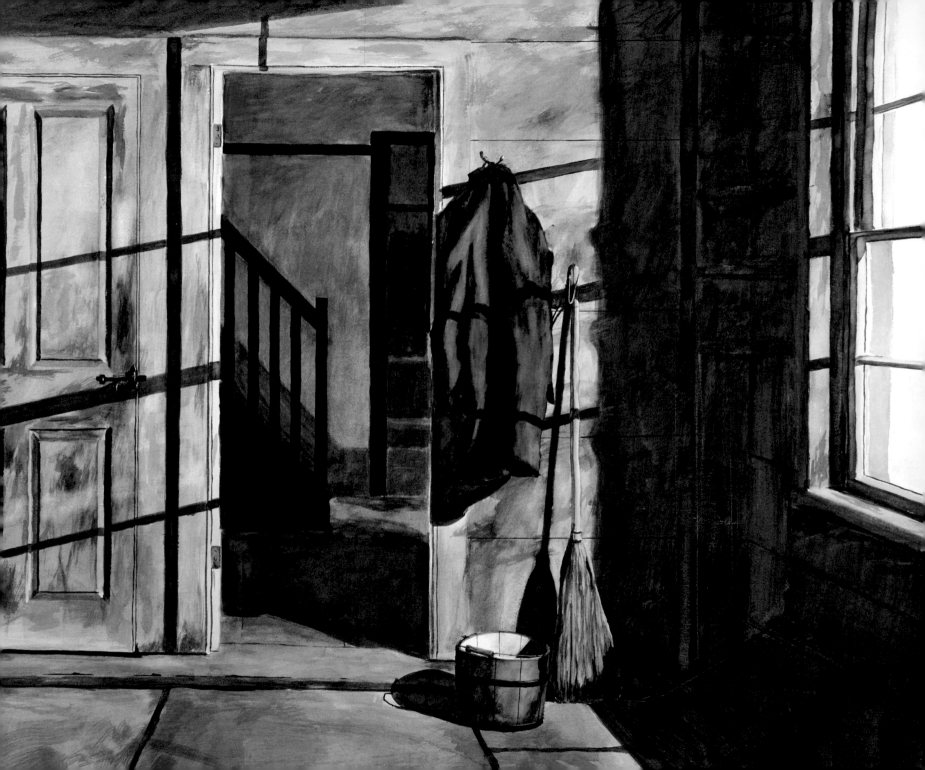

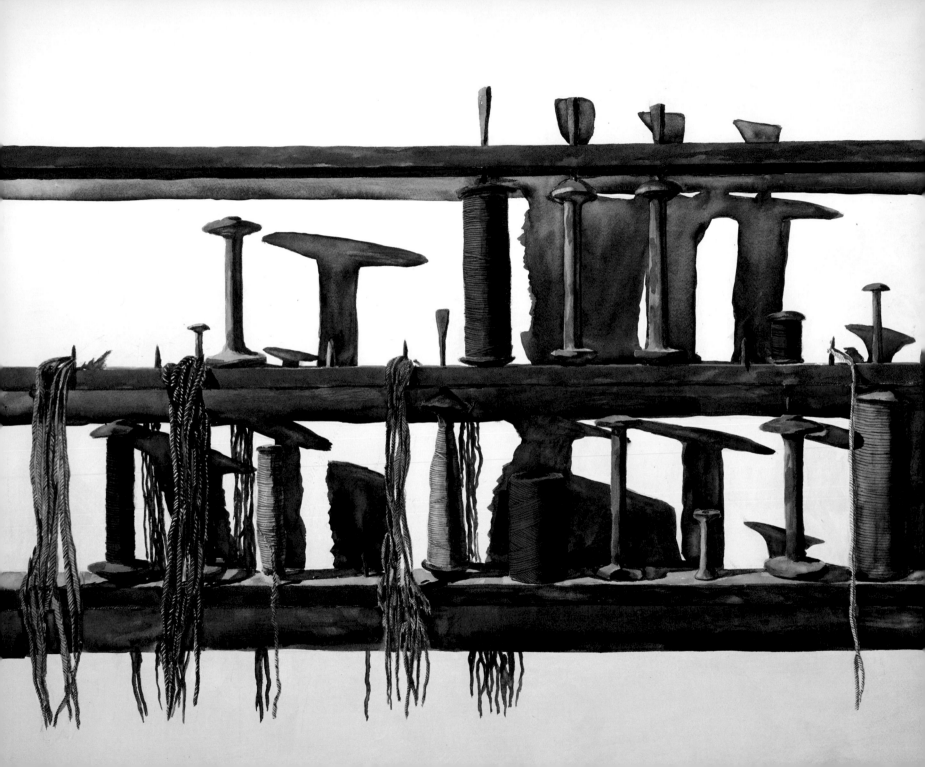

Spindles, 2019. Watercolor on paper, 29 ¾ x 41 inches

Sisters, 2019. Watercolor and drybrush on paper, 29 ¾ x 41 inches

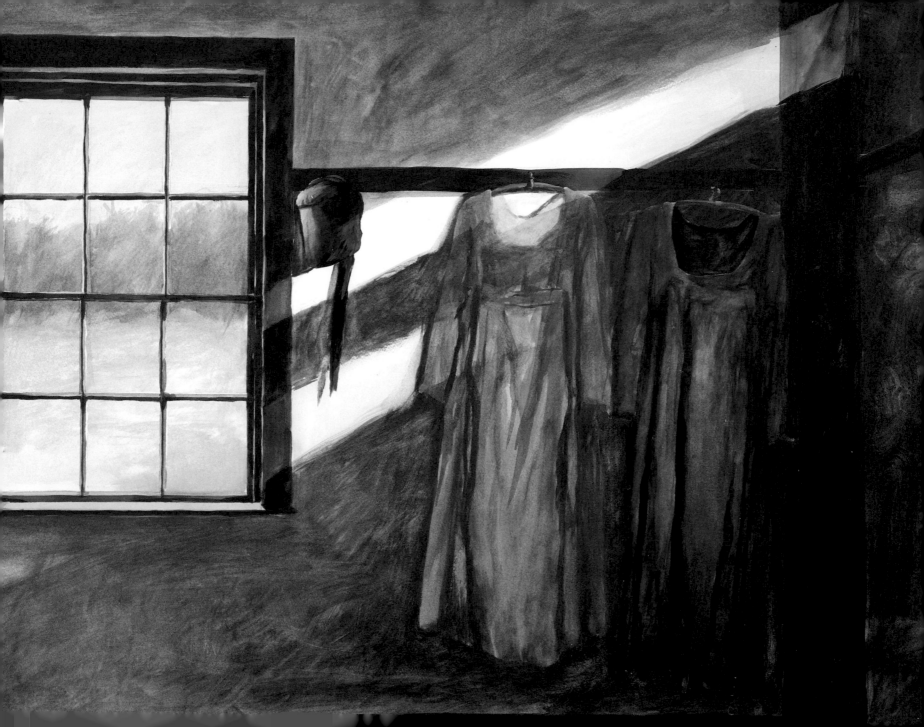

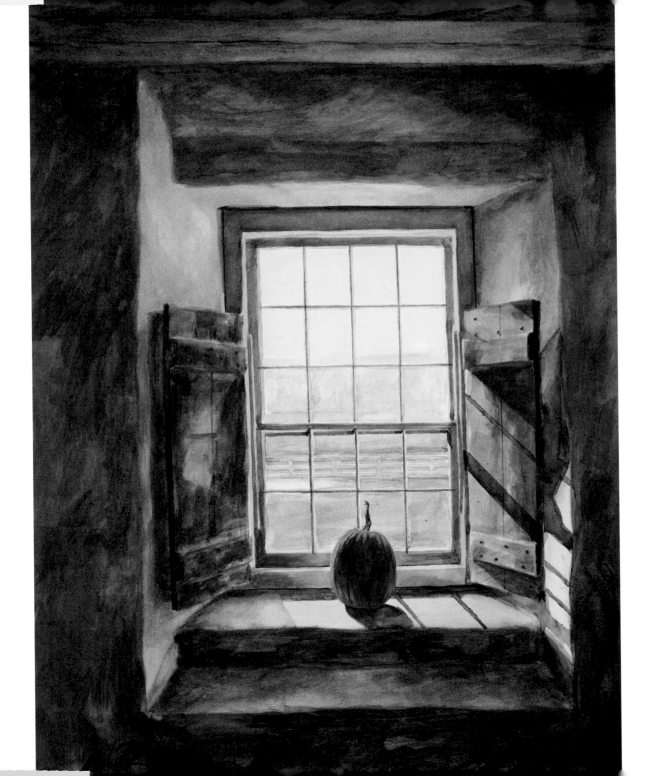

Day Dreamer, 2019. Watercolor and drybrush on paper, 30 x 22 inches

School Room Red Coat, 2019. Watercolor and drybrush on paper, 29 ¾ x 41 inches

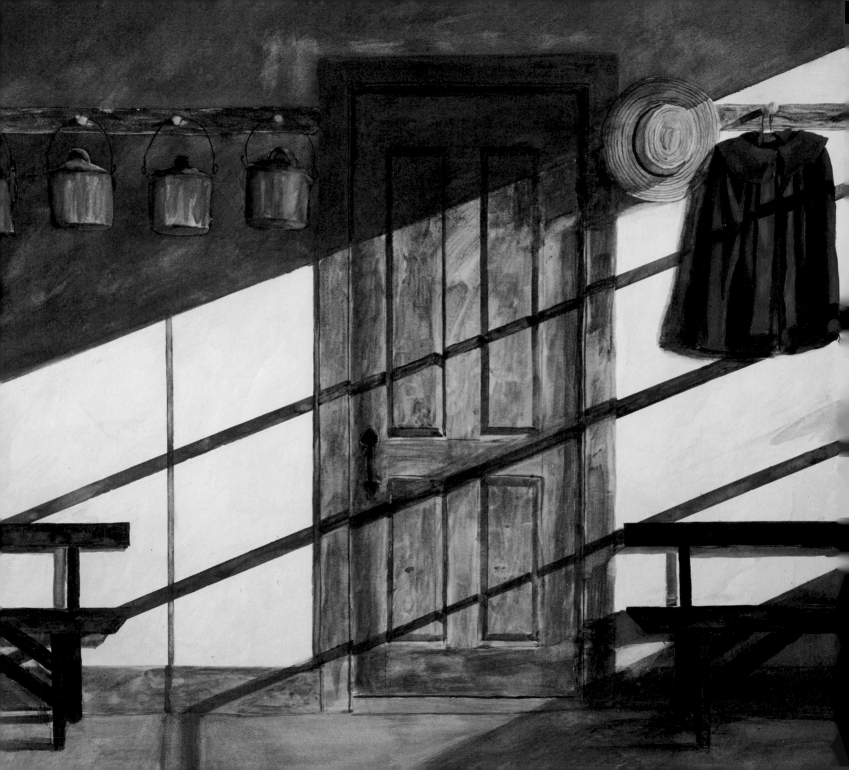

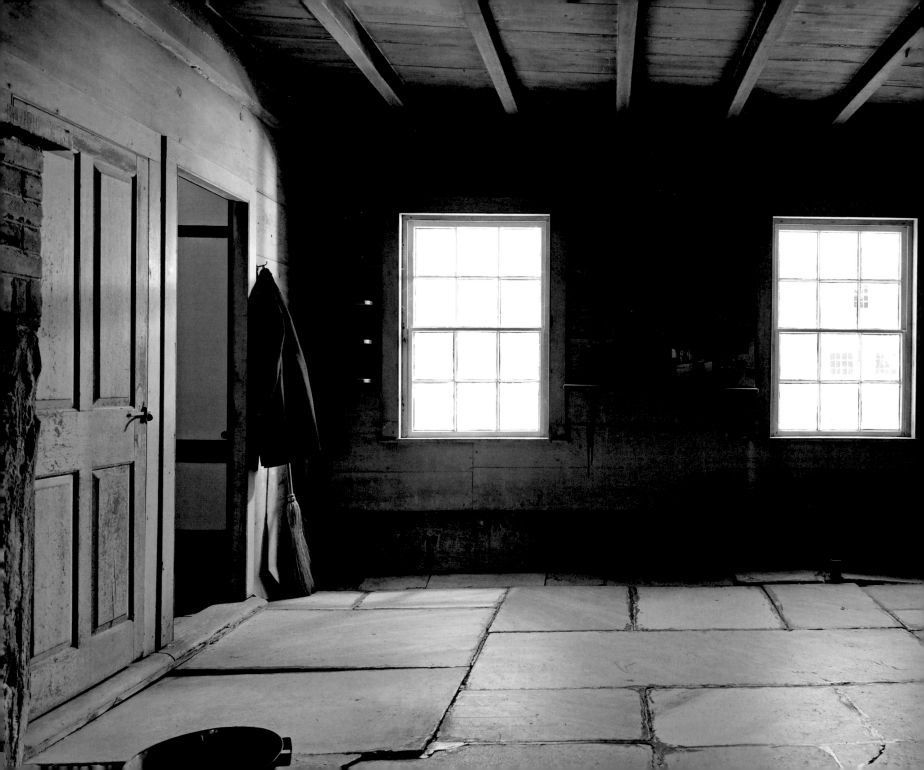

Interview with
Barbara Ernst Prey

Sarah Margolis-Pineo: *How did your upbringing, and your parents in particular, influence your life as an artist?*

Barbara Ernst Prey: My mother was head of the design department at Pratt Art Institute in New York. She had a large studio in our home where I had an easel set up to paint with her. When I was a child, she would take me out to paint with her on painting trips. She introduced me to the museums in New York whose collections were my early teachers. She was a great influence and role model—incredibly gifted, creative, and she thought outside the box. For example, she made the kitchen rug look like a Jackson Pollock painting by splattering it with paint.

In addition to my mother's work in design, she was a talented painter in New York City during a time when the art world was very male-dominated. I share with her that I have no female predecessors with whom to identify—beyond my mother that is. I'm working to change that by doing my own thing my own way.

Like my mother, my father was recognized in his field. Born in 1898, he was an academic, an entrepreneur, and one of the first in the field of orthodontia (and Columbia University faculty member) whose New York City practice attracted prominent international clients. He was an educated and worldly figure whose love of music, travel, and the outdoors influenced my life and work. His father and grandfather were both president of Luther Seminary in Saint Paul, a Minnesota college that his grandfather—my great-grandfather—founded as well, so I come from a line of highly educated theological scholars who have a historical connection with the beginnings of the Lutheran church in America.

SMP: *What is your relationship to the Berkshires?*

BEP: I went to Williams College, and that was where I fell in love with the Berkshires. I have a studio and home in Williamstown, and I am adjunct faculty at Williams College, so I'm still very connected. Williams has some of the finest faculty in the world. I was fortunate to work and develop a lifelong friendship with Lane Faison, who, with Whitney Stoddard and Bill Pierson, were the original "Williams art history mafia" (I'm one of the few females in

the group). With Lane, I did my honors thesis on southern German Baroque architecture—I did a lot of looking at floor plans and interior spaces.

I've always been interested in church history—particularly in New England, and I love how this history allows me to combine my academic interest in architecture and art history with my painterly love of color, light, form, and design. It was during my time as a student that I was introduced to the Shakers. I also continue to paint the Berkshires, which I have been doing for the past forty years.

After graduating from Williams, I received a Fulbright scholarship to continue studying architecture in Europe for a year and a half, always painting and looking as well. I then went to Harvard Divinity School, where I studied the ecclesiastical history that inspired the design and execution of religious art and architecture. After Harvard, I received a one-year grant from the Henry Luce Foundation to travel to Taiwan, where I taught at Tainan Theological College and Seminary and artistically explored the architecture of the local folk religions and their temples. So I've gone from monastic interiors and Baroque structures to Asian folk temples, from New England early meetinghouses to Shakers.

SMP: *Is there any aspect of Shaker design, architecture, or ideology that you find particularly inspiring?*

BEP: I've always been drawn to the simplicity of Shaker design. Maybe because I was immersed in Baroque for so long, I find myself drawn to a spiritual architecture stripped of all ornamentation. I've appreciated the Ming aesthetic as well. To me, Ming is on the same plane as Shaker in terms of beauty and simplicity. I'm also drawn to the handmade, which is something I equate with the Shakers. Particularly in this age when everything is so technologically driven, handmade objects speak to the soul and to the spirit. The Shaker objects in *Borrowed Light* are so beautifully utilitarian in their own right, but then they're incorporated into the unique history of the Shakers. I wonder: who were these artists and craftspersons? Their work really has survived the test of time.

SMP: *What is it about the medium of watercolor that seemed conducive to this project?*

BEP: Watercolor is considered a very difficult medium, and to paint a large painting in watercolor is challenging. In the case of *Shaker Barn,* I held my breath while creating those

big washes of sky. I wanted to achieve a strong blue sky over an expanse of white, so I couldn't make a mistake—no water drips! It took layers and layers to build that texture. Watercolor is a tactile medium. When you're painting with it, you're feeling the paper, and you need to maintain a balance between control and allowing for the unexpected to happen and improvise. The process is a bit free-spirited in that way. Oil painting is too heavy—it wouldn't work. Watercolor lends a transparency that, in the context of this series, is akin to a kind of spiritual transparency.

Like the Shakers, I love color. They worked with vibrant colors in their paints and dyes, and I achieve a similar brilliancy of pigment after the water disappears. Thinking about those stacks of bright oval boxes and that blue bucket, I really tried to push the color as strong as possible.

SMP: *What was the process for creating* Borrowed Light? *How was it informed by your time at Hancock Shaker Village, and how did it evolve in the studio?*

BEP: I approached this project in the way I approached my commission for NASA, the White House, and for MASS MoCA: with a lot of research. With the Shakers, I started by looking. I visited Hancock and other sites like Sabbathday Lake in Maine at various times throughout the year so I could see all four seasons. I was drawn to the incorporation of light into Shaker architecture. I did some sketching, but, really, I was looking at the light—what I consider on-site homework. Early in my career, I worked as an illustrator for magazines like *The New Yorker, The New York Times*, and *Good Housekeeping*, where I would read poems or articles and create illustrations. This was a similar process of reading the architecture and thinking deeply about it. I didn't try to put myself into the experience of being a Shaker; instead, I was looking at it from the outside as an observer.

Initially, I gravitated towards the Meetinghouse as the crux of the Shaker experience. I see it as the center of the community—the source of inspiration for work and everything else. I was also drawn to the spaces and concept of women's work—the Laundry and Sisters' Weave Shop in particular. I think part of the reason I was drawn to the threads in the weaving studio was because of my mother's work in textile design, and the colors on the spindles were so striking—creating abstract shadow shapes as the light streamed in. If you think about it, that space is a microcosm of Shaker life: they raised the crops and animals to make the fiber, grew the plants to make the dyes, spun the thread, wove the textile, sewed the jacket, and later washed the jacket,

all using tools that were handmade—down to the smallest hand-carved spool of thread.

SMP: *How did literal and metaphorical notions of light factor into this body of work?*

BEP: As a painter, I find that light is important to everything I create. It is my subject—light defines every line and object I put onto paper. Light, color, and design are really important. When I'm looking at architecture, essentially, I'm looking at light itself. In this way, all light is borrowed light.

At Harvard, and later as a NASA-commissioned artist, I thought deeply about what is beyond our world. That's what theologians and astronauts share, right? The desire to explore and figure out the universe. Light intersects both of these planes, the physical and spiritual, and lends a crucial tool to build our lives. I've always been interested in the greater existential questions of who we are, where we're going, why we're here, and what's important—what really matters. I think this is reflected in much of my work. *Borrowed Light* is influenced by Shaker design, spirit, and sense of community—we're all connected through community.

Artist Biography & Selected Exhibition History

BARBARA ERNST PREY

Born 1957, New York City, NY

Lives and works in Oyster Bay, NY, Williamstown, MA, and Tenants Harbor, ME

EDUCATION

1979 BA, Williams College, Williamstown, MA

1986 MDiv, Harvard University, Cambridge, MA

AFFILIATIONS, AWARDS & FELLOWSHIPS

2013-present
Adjunct Faculty, Williams College, Williamstown, MA

2008-present
Presidential Appointed Member, National Council on the Arts

2004 New York State Senate Women of Distinction Award

1986 Henry Luce Foundation grant

1979 Fulbright Scholarship, Germany

1974 Grant Recipient, San Francisco Art Institute, San Francisco, CA

SELECTED EXHIBITIONS

2018

NASA 60th Art Exhibit, Space Center, Houston, TX

True Colors, Nassau County Museum of Art, Roslyn Harbor, NY

Earth, Sea, Sky, Wendell Gilley Museum, Southwest Harbor, ME

2017

Building 6 Portrait: Interior, MASS MoCA, North Adams, MA (2017-present)

Out Painting. Old Westbury Gardens, Old Westbury, NY

U.S. Mission to the United Nations, New York, NY (2017-present)

2016

OUT OF THIS WORLD. The Art and Artists of NASA, Vero Beach Museum, Vero Beach, FL

ON SITE: Barbara Ernst Prey's Travelogues, Barbara Prey Projects, Port Clyde, ME

In Search of America, Barbara Prey Projects, Port Clyde, ME

Prints and New Oils, Barbara Prey Projects, Port Clyde, ME

United States Arts in Embassy Program, Bridgetown, Barbados (2016-present)

2015

United Nations, New York, NY (2015-2016)

United States Art in Embassies Program, Baku, Azerbaijan (2015-2018)

Re/Viewing the American Landscape, Blue Water Fine Arts, Port Clyde, ME

George H.W. Bush Presidential Library, College Station, TX (2015-present)

2014

United States Art in Embassies Program, Hong Kong (2014-2016)

Barbara Prey: American Contemporary, Blue Water Fine Arts, Port Clyde, ME

2013

George H.W. Bush Presidential Library, Office of the First Lady, College Station, TX (2013-present)

East Meets West, Blue Water Fine Arts, Port Clyde, ME

2012

Nocturne IV, the Heckscher Museum of Art, Huntington, NY

America's Artist: Forty Years of Painting, Blue Water Fine Arts, Port Clyde, ME

2011

NASA|Art: 50 Years of Exploration, Smithsonian National Air and Space Museum, Washington, DC (Smithsonian traveling exhibition)

National Endowment for the Arts, Office of the Chairman, Washington, DC (2011-present)

Open Spaces, Blue Water Fine Arts, Port Clyde, ME

2010

United States Art in Embassies Program, Bamko, Mali (2010-2013)

Soliloquy: Meditations on the Environment, Blue Water Fine Arts, Port Clyde, ME

2009

25 Years Exhibiting in Maine, Blue Water Fine Arts, Port Clyde, ME

2008

An American View: Barbara Ernst Prey, Mona Bismarck Foundation, Paris, France

Meditations on the Environment, Blue Water Fine Arts, Port Clyde, ME

2007

Picturing Long Island, the Heckscher Museum of Art, Huntington, NY

United States Art in Embassies Program, Vilnius, Lithuania (2007-2009)

Works on Water, Water Street Gallery, Seamen's Church Institute, New York, NY

From Port Clyde to Paris, Blue Water Fine Arts, Port Clyde, ME

2006
From Seacoast to Outer Space, the Williams Club, New York, NY

Works on Water, Water Street Gallery, New York, NY

30 Years of Painting Maine, Blue Water Fine Arts, Port Clyde, ME

2005
United States Art in Embassies Program, Paris, France (2005-2009)

United States Art in Embassies Program, Madrid, Spain (2005-2009)

Works on Water, Blue Water Fine Arts, Port Clyde, ME

2004
United States Art in Embassies Program, Oslo, Norway (2004-2005)

Observations, Harrison Gallery, Williamstown, MA

Conversations, Blue Water Fine Arts, Port Clyde, ME (2004-2005)

2003
The White House, Washington, DC (2003-2006)

An American Portrait, Arts Club of Washington DC, Washington, DC

United States Art in Embassies Program, Minsk, Belarus (2003-2005)

United States Art in Embassies Program, Monrovia, Liberia (2003-2005)

Kennedy Space Center, NASA Commissions, Titusville, FL (2003-present)

The Valley Viewed: 150 Years of Artists Exploring Williamstown, Harrison Gallery, Williamstown, MA

Guild Hall Museum, East Hampton, NY (2003-2006) National Arts Club, New York, NY

25 Years of Painting Maine, Blue Water Fine Arts, Port Clyde, ME

2002
United States Art in Embassies Program, Prague, Czech Republic (2002-2003)

United States Art in Embassies Program, Oslo, Norway (2002-2004)

Obsession, the Heckscher Museum of Art, Huntington, NY

Patriot, Blue Water Fine Arts, Port Clyde, ME

A Trace in the Mind of an Artist's Response to 9/11, Hutchins Gallery, C.W. Post College, Brookville, NY

2001
Lightscapes, Jensen Fine Arts, New York, NY

Guild Hall Museum, East Hampton, NY (2001-2002)

Recent Watercolors, Blue Water Fine Arts, Port Clyde, ME

1999
Recent Watercolors, Jensen Fine Arts, New York, NY

The Heckscher Museum of Art, Huntington, NY

Guild Hall Museum, East Hampton, NY (1999-2006)

1998
American Art in Miniature, Gilcrease Museum, OK (1998-2002)

Express Yourself, Portland Museum of Art, Portland, ME

1997
Museum of the Southwest, Midland, TX

Recent Acquisitions, Farnsworth Museum of Art, Rockland, ME

1996
Best in Show, Westmoreland Museum of American Art, Greensburg, PA

1995
Philadelphia Museum of Art, Philadelphia, PA

1993
Blair Art Museum, Hollidaysburg, PA

Johnstown Art Museum, Johnstown, PA

1989
Women's Art, Williams College Museum of Art, Williamstown, MA

1988
Nassau County Museum of Art, Roslyn Harbor, NY

1986
Harvard University, Cambridge, MA

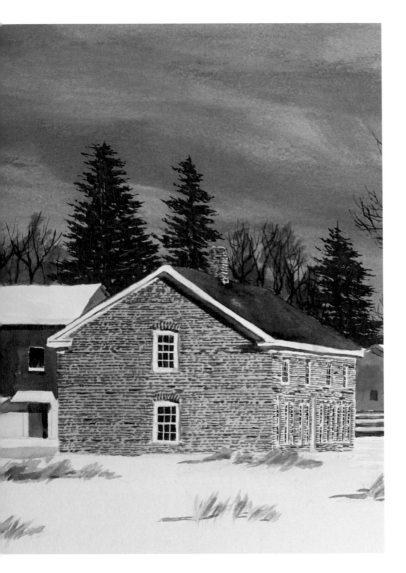

SELECTED COLLECTIONS

Mrs. C. Robert Allen

Mr. Orlando Bloom

Brooklyn Museum

Mr. Sam Bronfman

President and Mrs. George H.W. Bush

Mr. and Mrs. Russell Byers, Jr

Prince and Princess Castell

Ambassador and Dr. Struan Coleman

Mr. and Mrs. Boomer Esiason

Farnsworth Art Museum

Mr. and Mrs. Alan Fulkerson

Senator and Mrs. Judd Gregg

Hall Art Foundation

Mr. and Mrs. Tom Hanks

Harvard Business School

Henry Luce Foundation

Hood Museum, Dartmouth College

Mr. Franklin Kelly

Kennedy Space Center

Prince and Princess Johannes Lobkowicz

MASS MoCA

NASA Headquarters

The National Endowment for the Arts

National Gallery of Art

The New York Historical Society Museum

Mr. Peter O'Neill

Ambassador and Mrs. John Ong

Mr. and Mrs. Howard Phipps, Jr.

Ambassador and Mrs. Mitchell Reiss

Prince and Princess Michael Salm

Smithsonian American Art Museum

Ambassador and Mrs. Craig Stapleton

Taiwan Museum of Art

Dr. and Mrs. Jim Watson

Mr. and Mrs. Jimmy Webb

The White House

Williams College Museum of Art

Checklist

Day Dreamer, 2019
Watercolor and drybrush on paper
30 x 22 inches

Day's Work, 2019
Watercolor and drybrush on paper
40 x 60 inches

Channeled Light, 2019
Watercolor and drybrush on paper
38 ½ x 58 ½ inches

Red Cloak Blue Bucket, 2019
Watercolor and drybrush on paper
29 ¾ x 41 inches

School Room Red Coat, 2019
Watercolor and drybrush on paper
29 ¾ x 41 inches

Shaker Barn, 2019
Watercolor and drybrush on paper
40 x 60 inches

Sisters, 2019
Watercolor and drybrush on paper
29 ¾ x 41 inches

Spindles, 2019
Watercolor on paper
29 ¾ x 41 inches

Wood Work, 2019
Watercolor and drybrush on paper
40 x 60 inches

Work of Whimsy, 2019
Watercolor and drybrush on paper
29 ¾ x 41 inches

All works courtesy of Barbara Prey Studio
Photography © Barbara Prey Studio

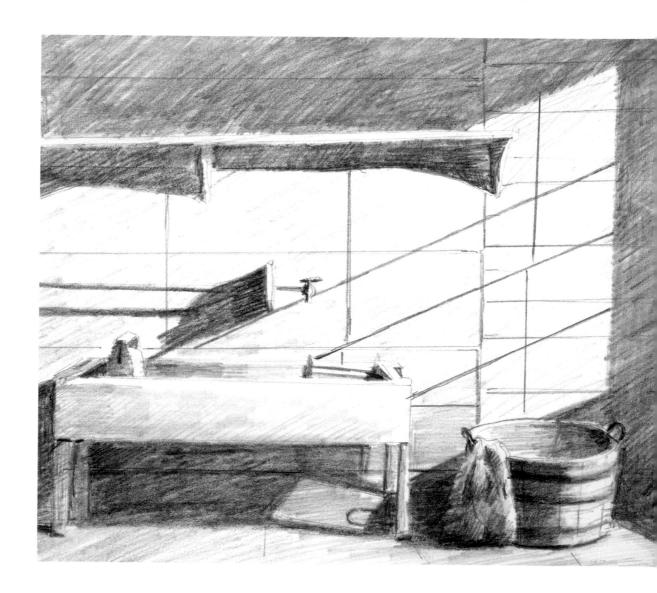

Acknowledgements

Hancock Shaker Village is grateful to the sponsors of this exhibition: Herbert Allen, Duncan and Susan Brown, Paul Neely, Balance Rock Investment Group, and Sheila Stone.

Our heartfelt thanks, too, to the Hancock Shaker Village trustees, members, and staff whose support makes exhibitions such as *Borrowed Light: Barbara Ernst Prey* possible. A special thanks to Sarah Margolis-Pineo for curating this beautiful show, as well as others who worked directly on the show, including Jennifer Austin, Dante Birch, Ruth Burday, Maribeth Cellana, Kristen Baker Dominguez, Cindy Dickinson, Erin Hunt, Bill Mangiardi, Suzanne Maslanka, Leslie Pizani, Amanda Powers, Billy Schilling, Hannah Schockmel, Russell Sorrell, Caitlin Spara, and Emily Sylvia. An exhibition takes many people working together—from the facilities person plowing the parking lot (yes, it snows in April) to the development office organizing the opening reception—and Hancock Shaker Village has an extraordinary team.

Finally, our deepest appreciation to Barbara Ernst Prey, who made the Village her own in the most exquisite way.